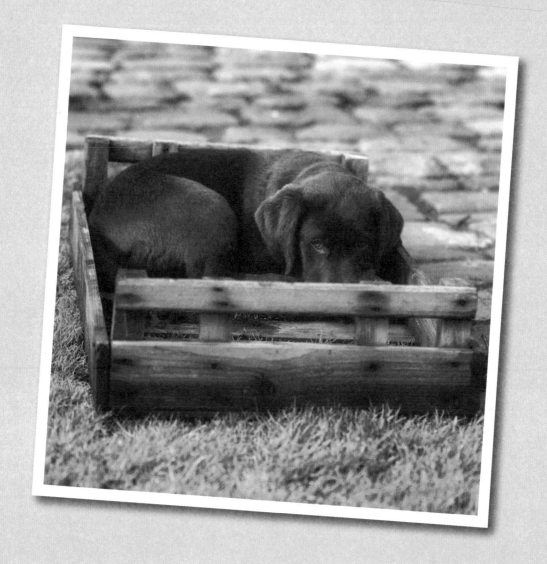

labradorable

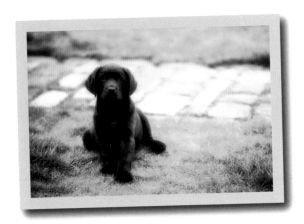

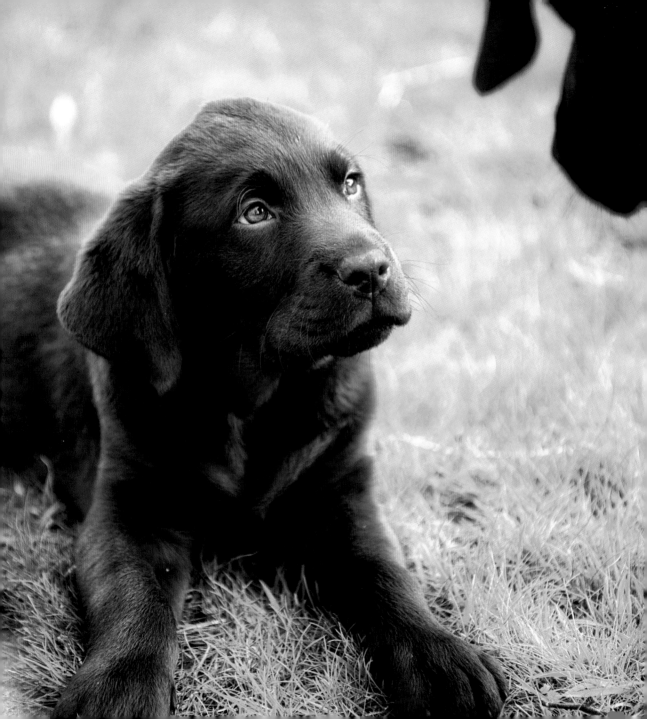

labradorable

Labradors at home, at large, and at play

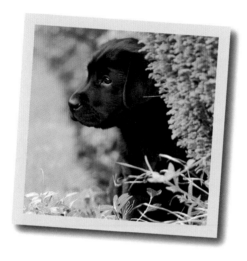

Villager Jim

CICO BOOKS

LONDON NEW YORK

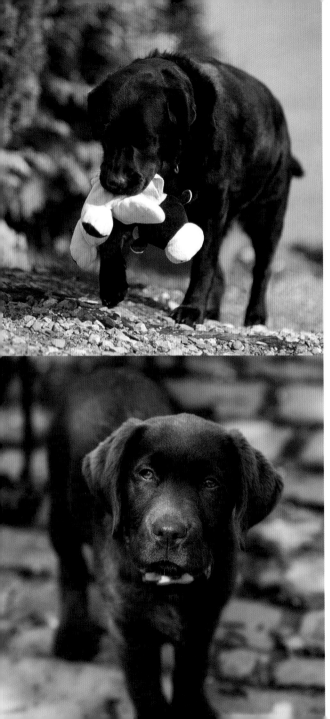

I dedicate this book to my late father, who loved seeing my pictures, which I sent him every week. He did not get to see my business grow, and I know he would have been so proud. Dad bought us our first labrador, called Brutus, when I was six years old, and it started a life-long love of the breed. This is for you, Dad xx

Published in 2015 by CICO Books
An imprint of Ryland Peters & Small Ltd
20–21 Jockey's Fields 341 E 116th St
London WC1R 4BW New York, NY 10029

www.rylandpeters.com

10 9 8 7 6 5 4 3 2 1

Text and photography © Villager Jim
Design © CICO Books 2015

A CIP catalog record for this book is available from the Library of Congress and the British Library.

ISBN: 978 1 78249 275 7

Printed in China

Designer: Geoff Borin

In-house designer: Fahema Khanam
Art director: Sally Powell
Head of production: Patricia Harrington
Publishing manager: Penny Craig
Publisher: Cindy Richards

contents

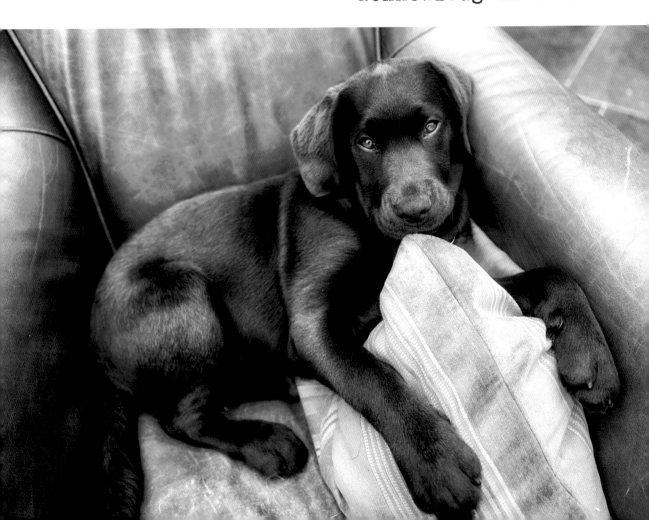

introduction

Villager Jim is a wildlife and countryside photographer living in the Peak District National Park in the north of England, a stunning location full of picturesque villages and wonderful farmland. Jim lives in one of these villages with his family and three scrumptious labradors, Dilly, Bumble, and Barnaby.
His daily adventures delight his online following and the most popular updates of all are those featuring the dogs. Barnaby is

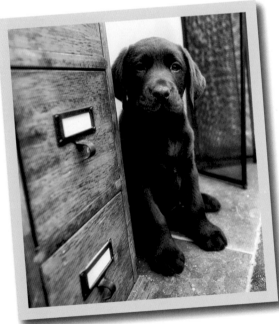

the latest addition to the family and we hope you enjoy seeing him explore and grow, under the watchful eye of his older sisters, in the wonderful world of Villager Jim's farm.
We hope you find these photographs "labradorable," but don't be fooled—with eyes and expressions that could melt your heart from 50 paces, these little monkeys really do get up to some serious mischief!

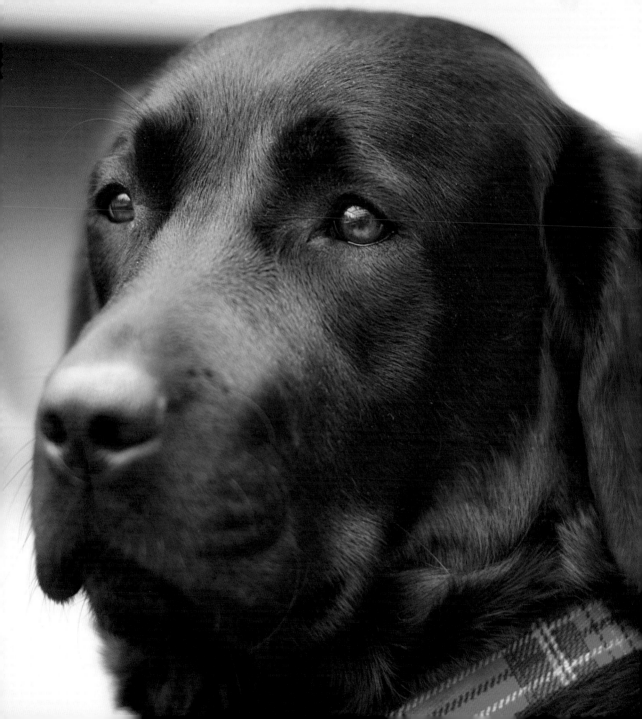

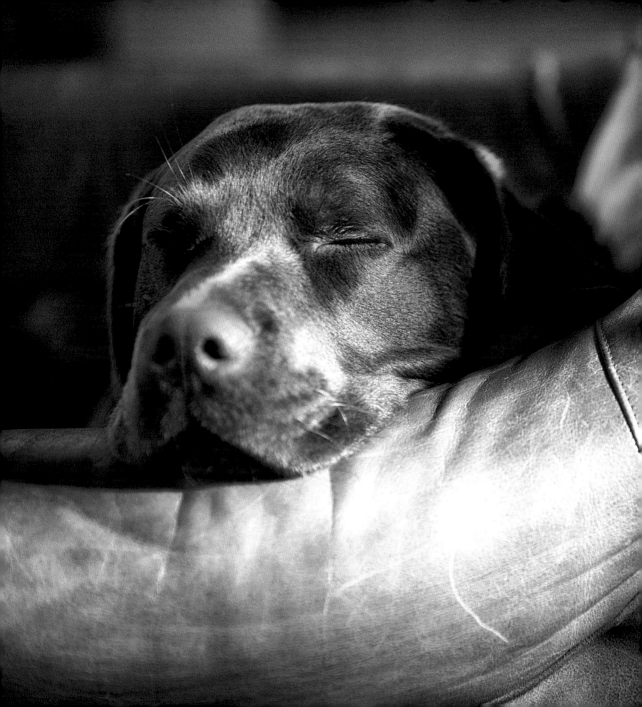

at home

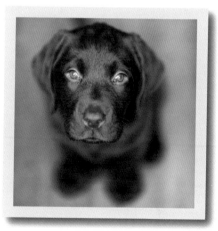

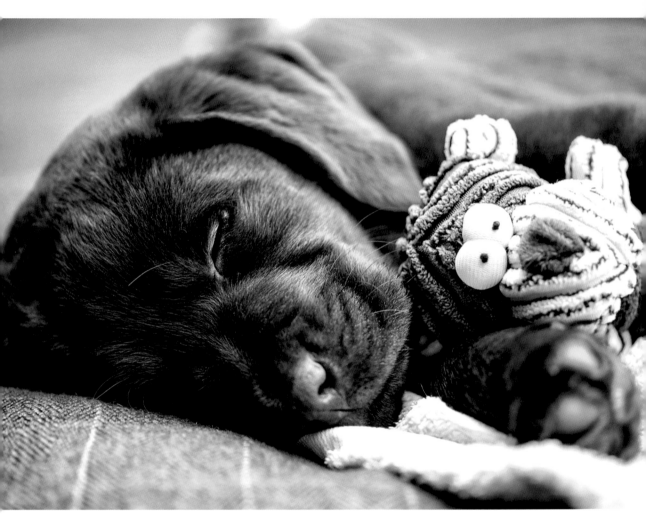

Barnaby snoozes away, dreaming of running with his sisters (and being chased by a brown and white tiger with bobble eyes).

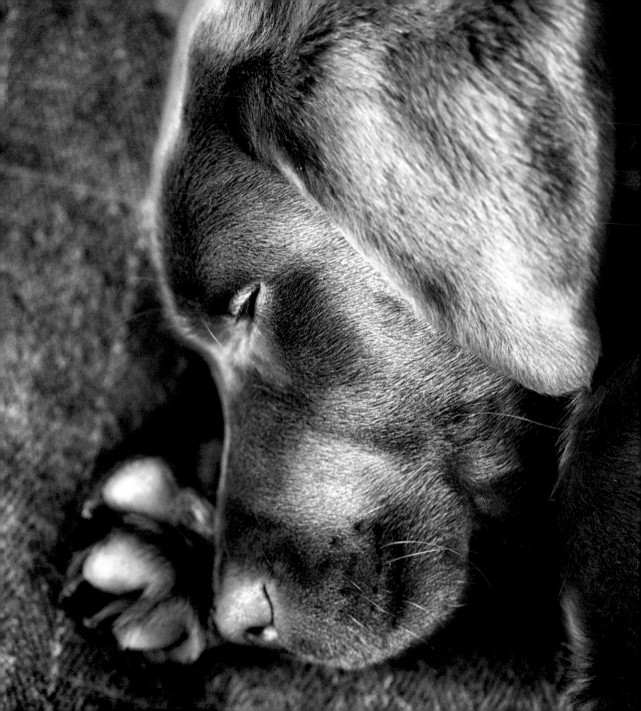

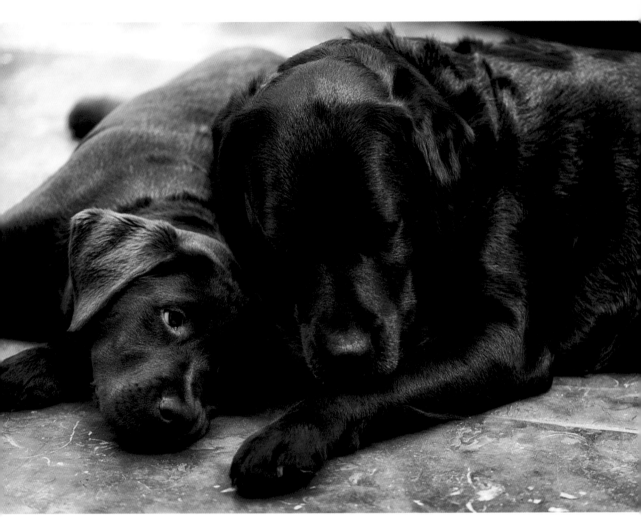

Big sister worship! Dilly and Bumble took to Barnaby straight away.

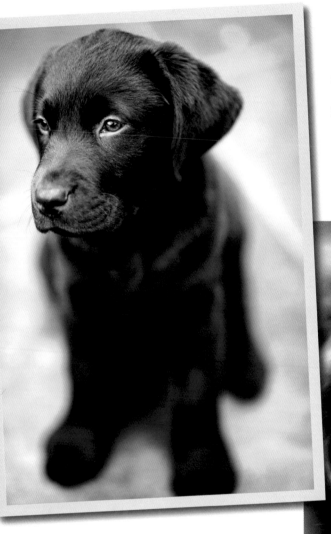

Barnaby in his wide-awake mode
(left) and then deep in slumber
30 seconds later!

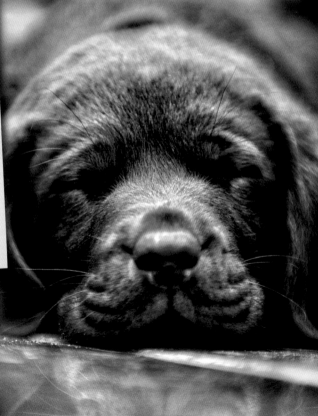

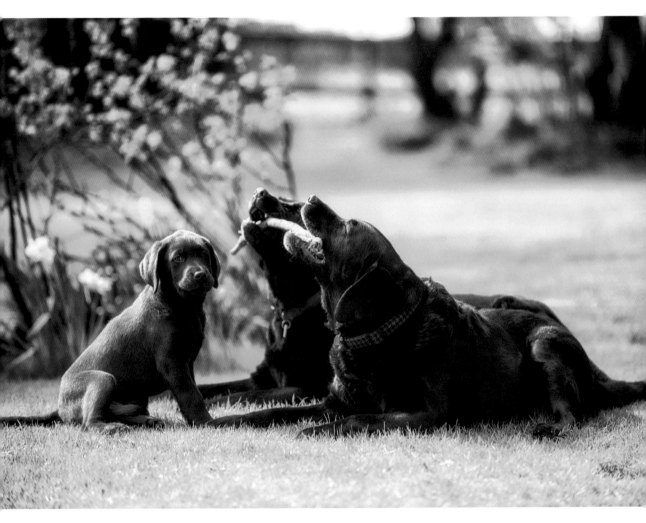

If you're a really clever puppy,
you can train your big sisters to
hold your stick for you.

Watching the garden birds is
great fun. Dilly has seen it
all before though...

14 at home

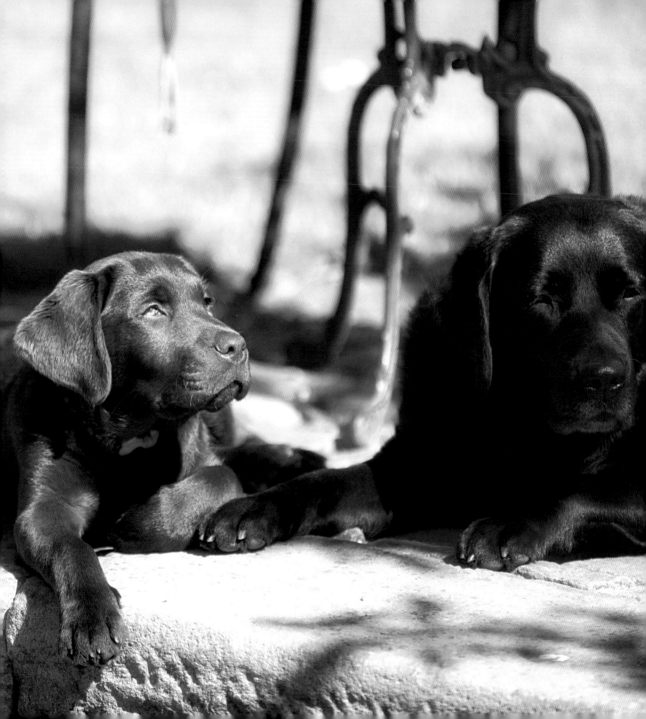

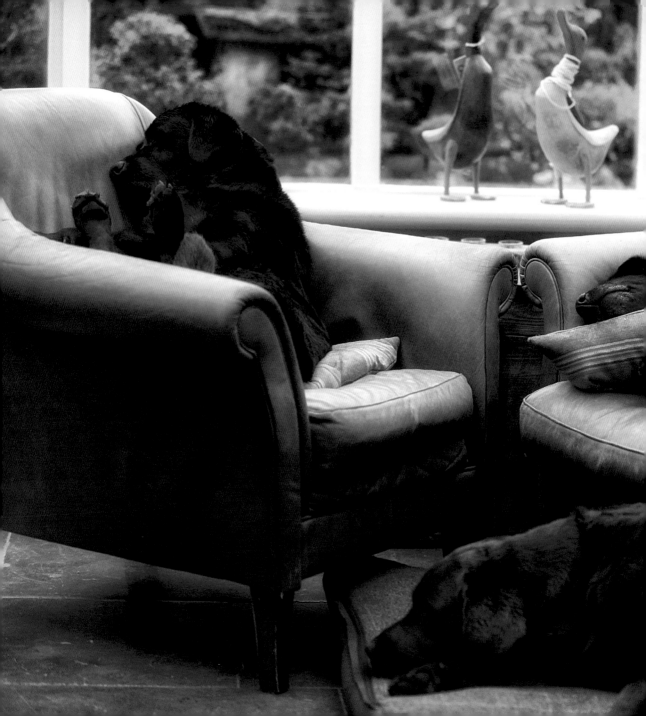

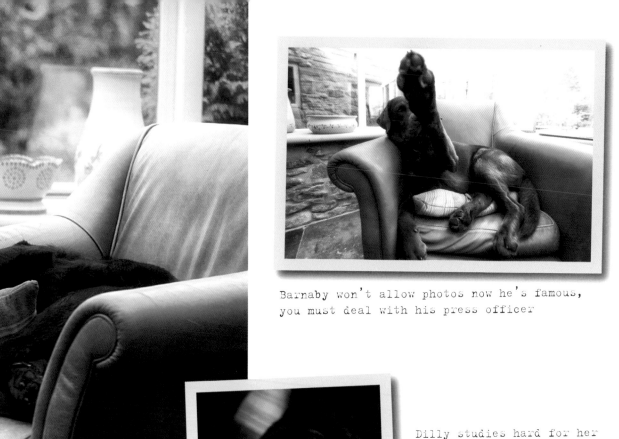

Barnaby won't allow photos now he's famous, you must deal with his press officer

Dilly studies hard for her exams. She specializes in Sleeping and Snoozing, and is thinking of taking the Napping course too.

"Let sleeping dogs lie" is the saying, and I can't disagree!

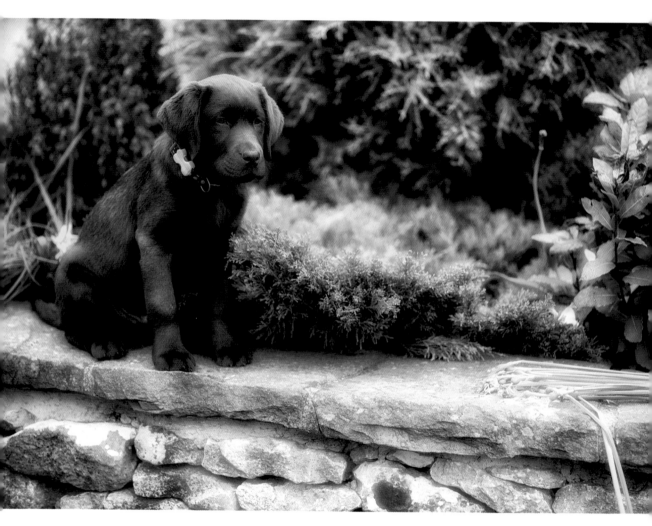

Playing at garden statues is so much fun, and if you stay still long enough you may even be lucky enough to see a passing chicken.

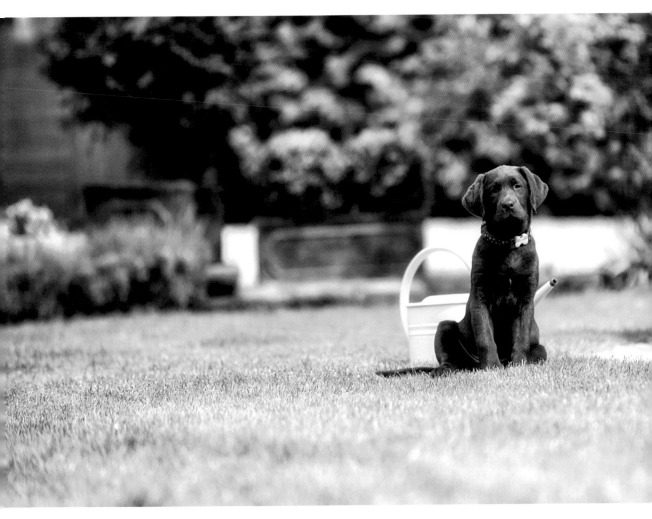

Hunting rabbits and tennis balls is always helped
by disguising yourself as a watering-can spout.

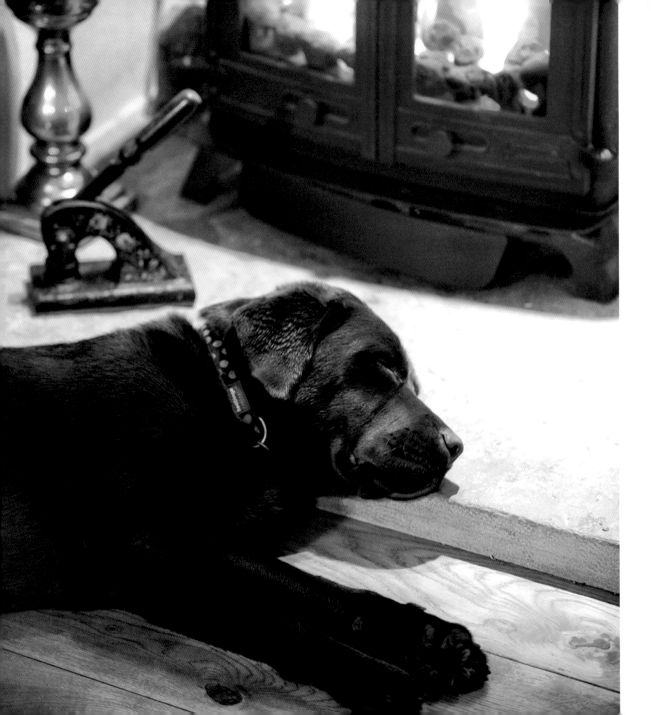

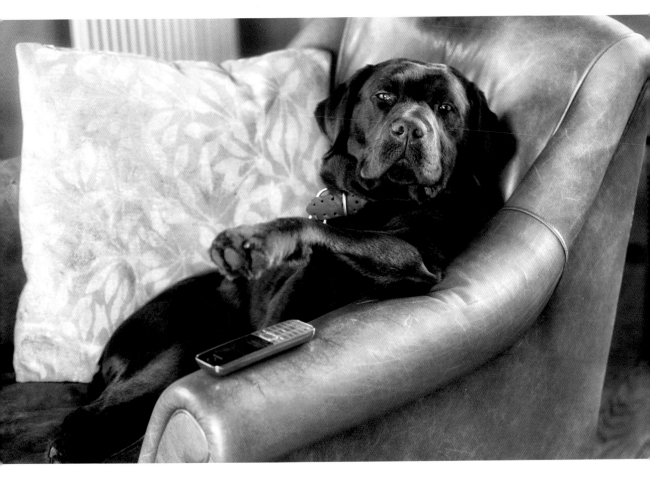

Barnaby now refuses to take calls from followers. His
phone buzzes daily with calls from female fans, but his
busy schedule doesn't allow him any lady time just yet.

For Barnaby, nothing beats a day in the country,
a big bowl of food, and sleeping in front of a
roasting fire as the wind whistles outside.

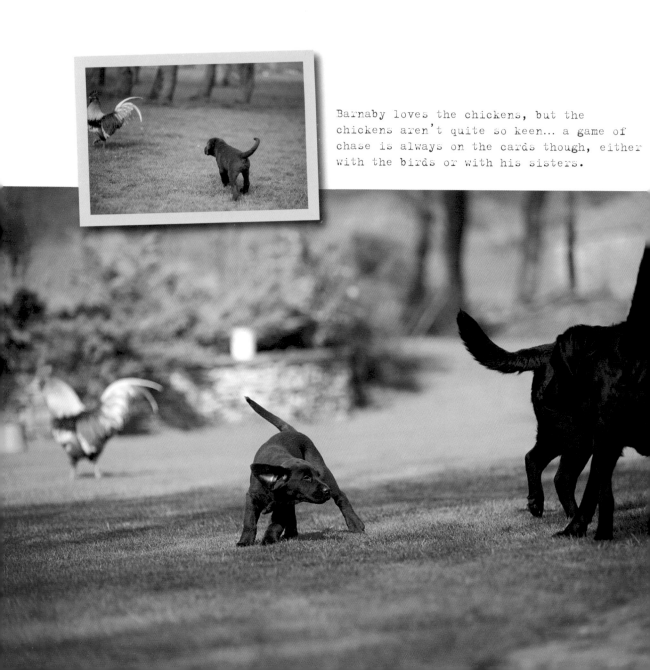

Barnaby loves the chickens, but the chickens aren't quite so keen... a game of chase is always on the cards though, either with the birds or with his sisters.

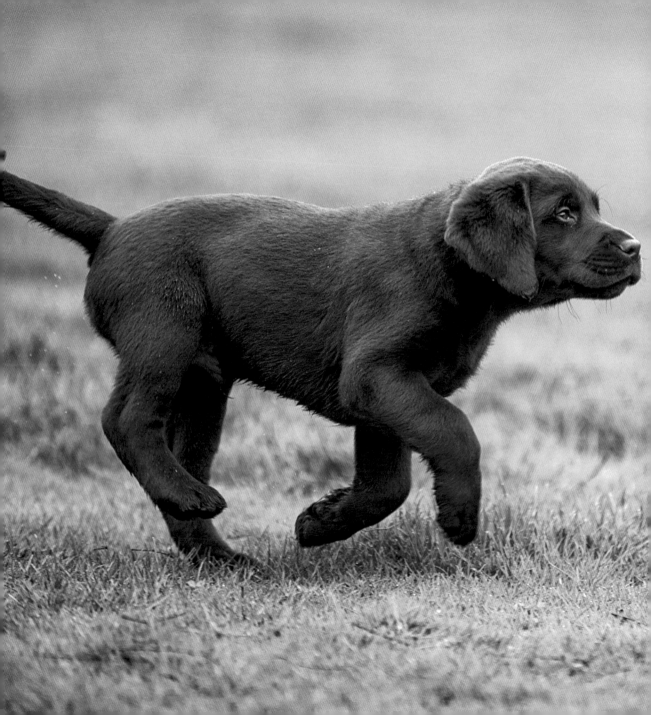

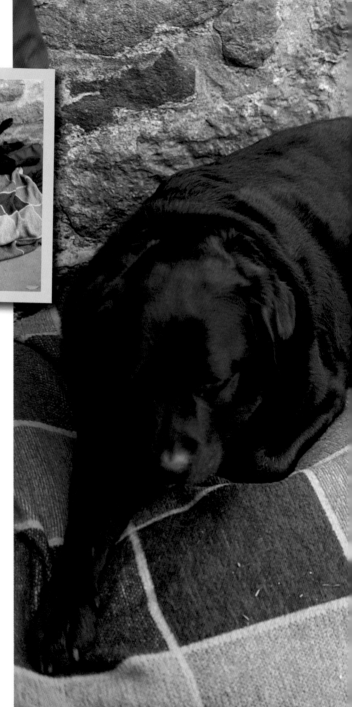

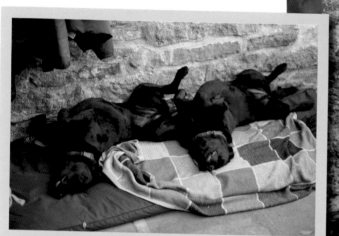

Synchronized sleeping is all the rage you know! Dilly, Bumble, and Barnaby are in training for the day it becomes an Olympic sport.

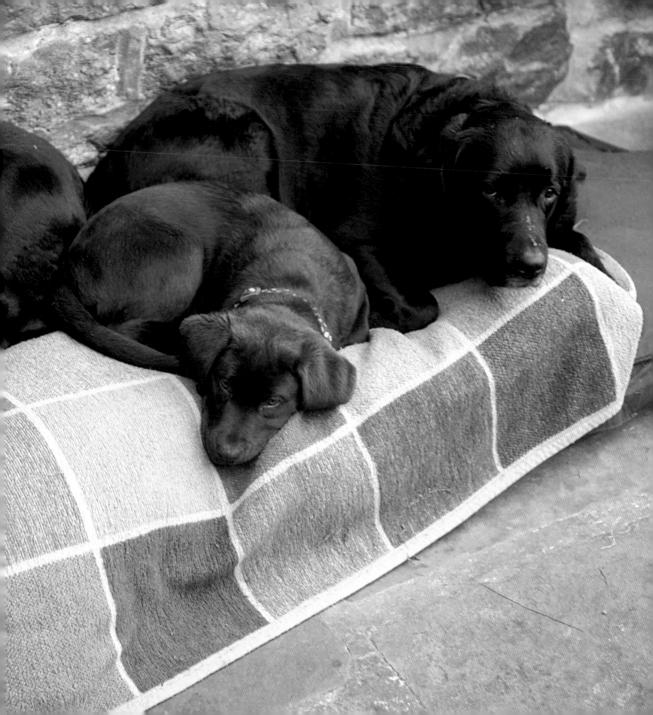

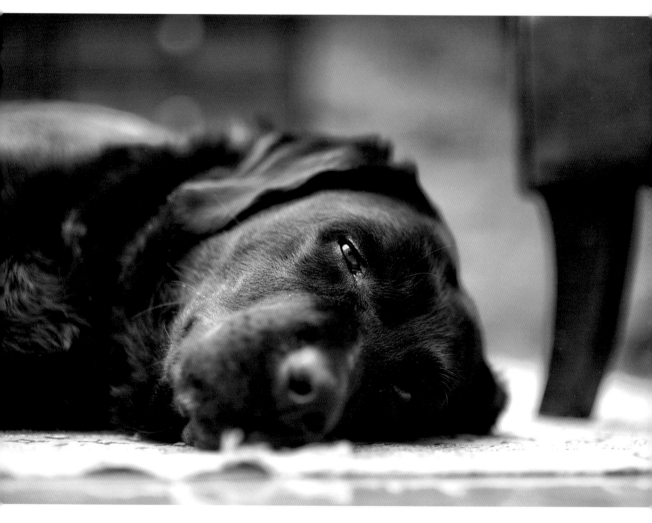

Being asleep but also just enough awake to hear
food-bowls clanging is a difficult art, but one
that Dilly has mastered very well.

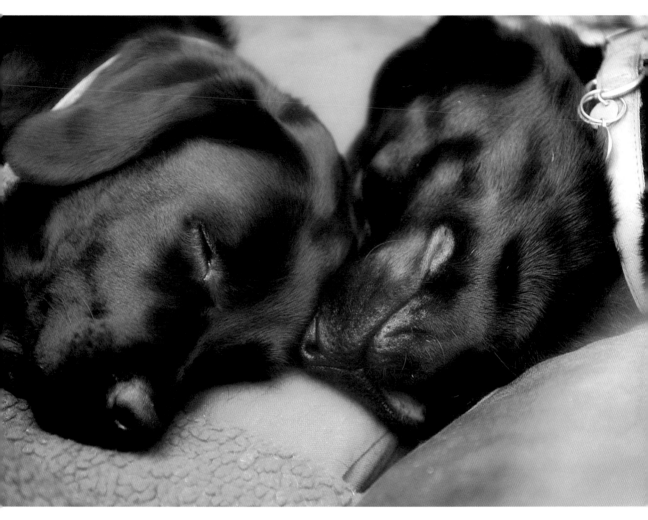

Sleeping Sisters: Bumble and Dilly catch 40 winks between Barnaby invasions.

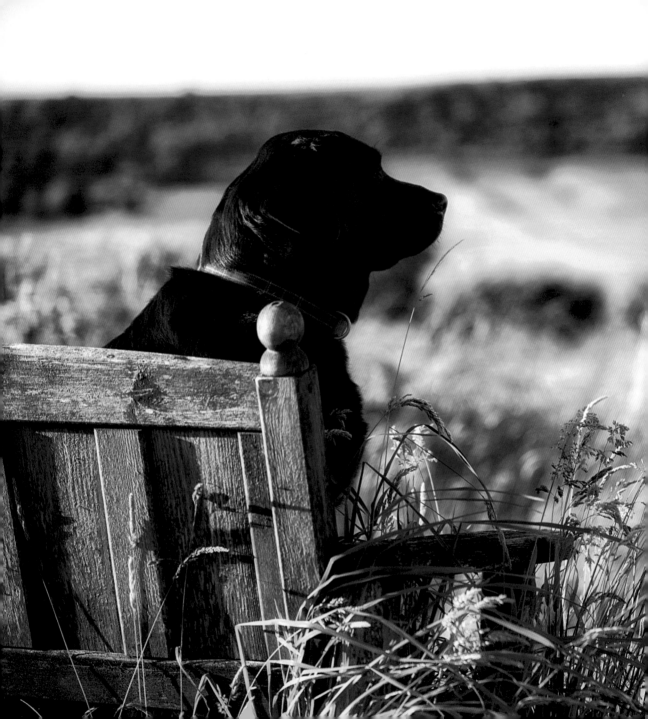

at large

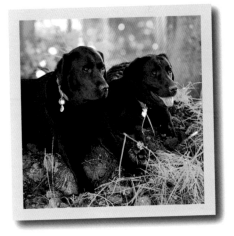

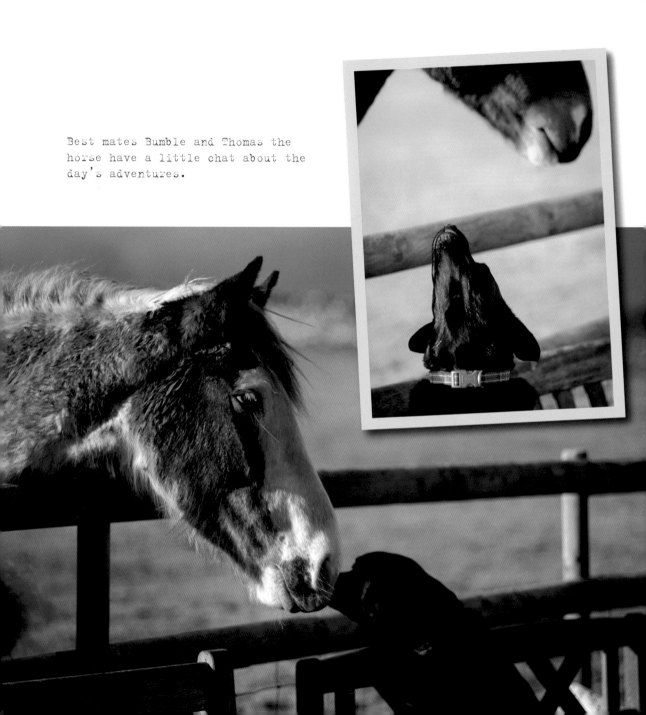

Best mates Bumble and Thomas the horse have a little chat about the day's adventures.

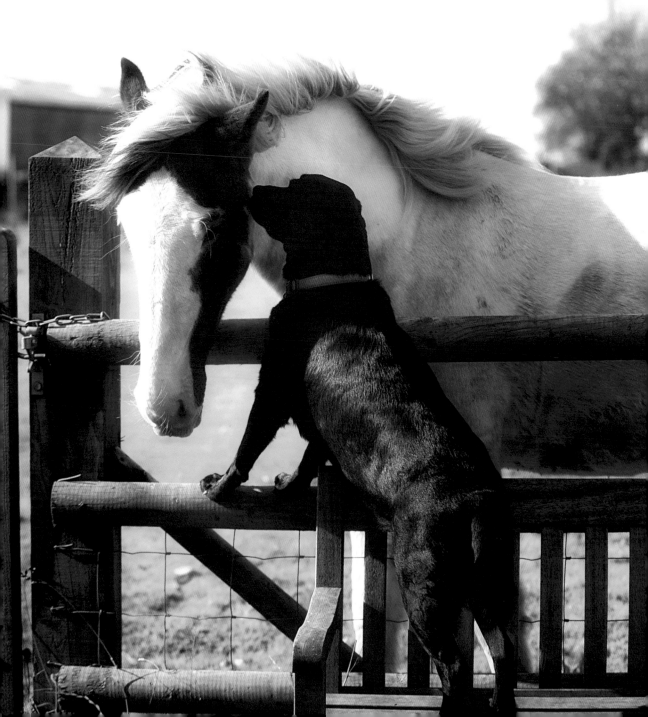

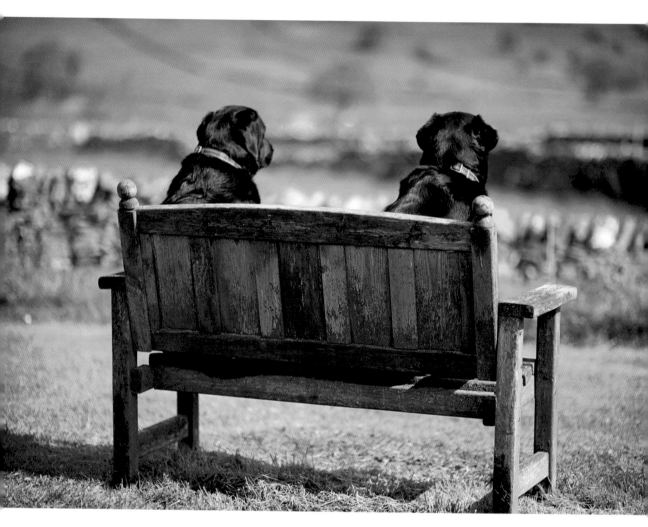

Two Fat Ladies survey the scene from their favorite bench.

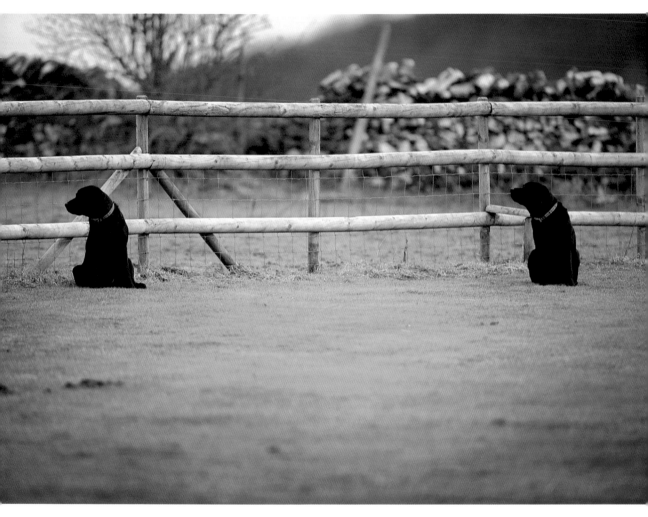

"Did someone say 'dinner'?"

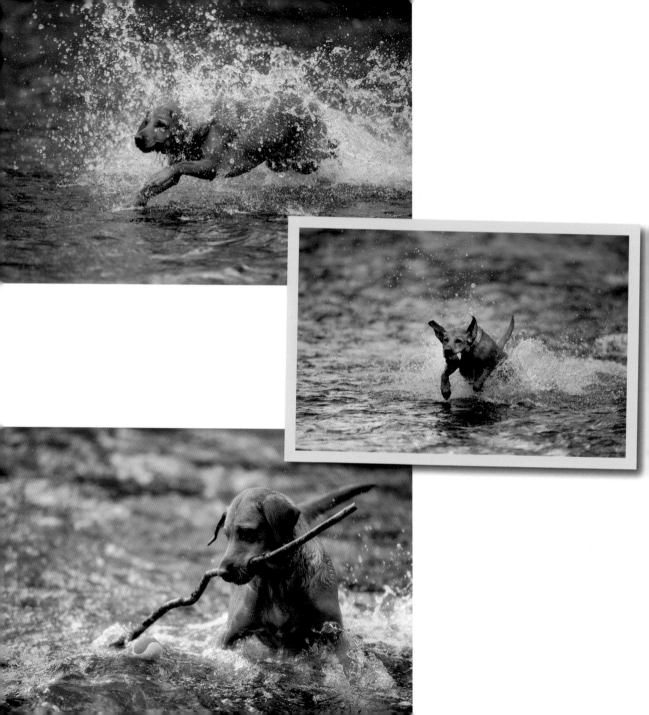

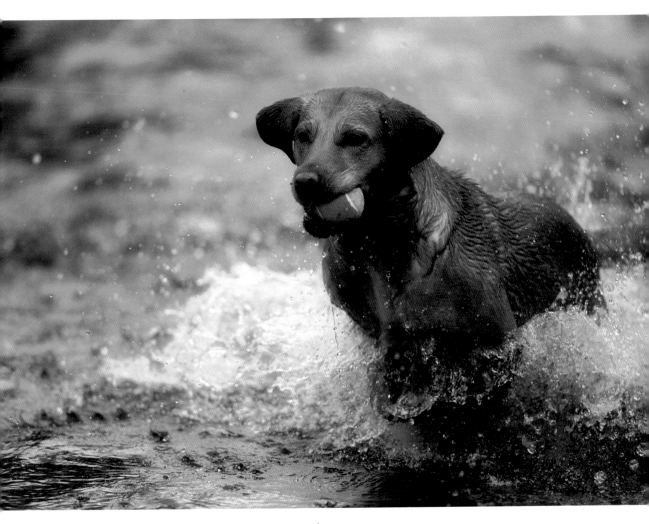

Ruby the Fox Red Labrador is now Barnaby's
bestest-ever buddy. Ruby is trying to teach him
how to swim and splash big time.

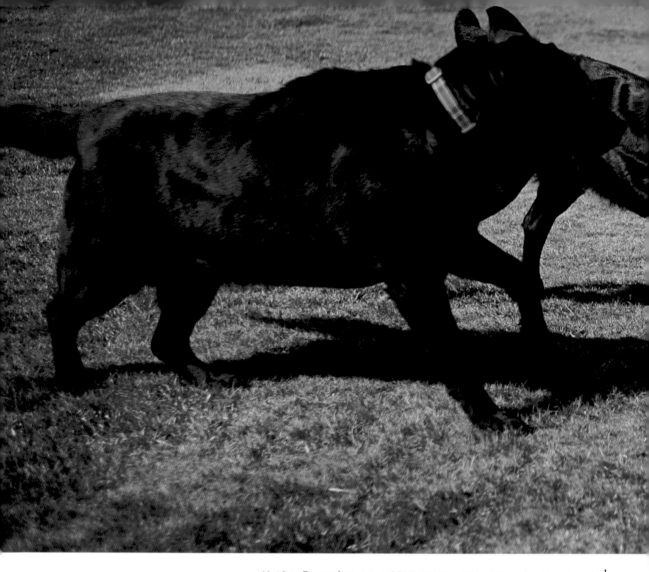

While Barnaby is off having swimming lessons, it's
time for the grown-ups to go mad for five minutes!

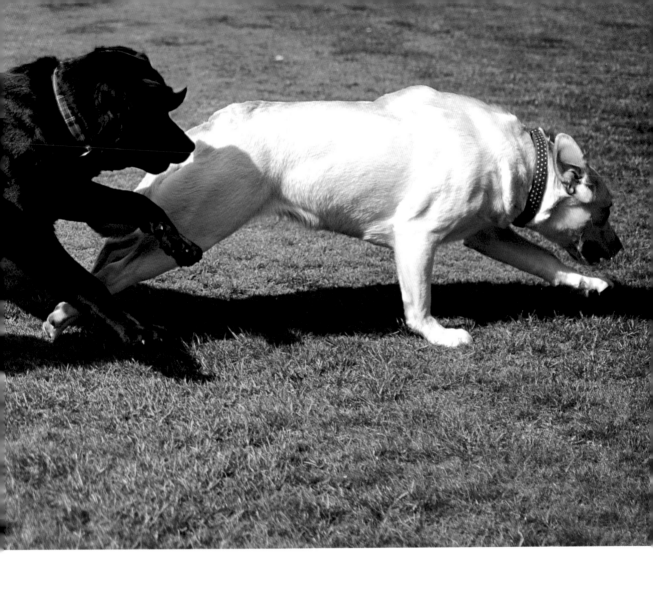

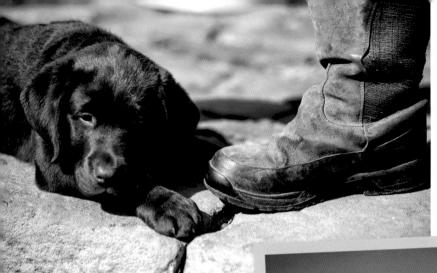

Barnaby is learning magic at the moment—his party trick is making sticks levitate!

"Being in the garden with my Mum is great—unless you meet a really pesky fly that makes you go cross-eyed!"

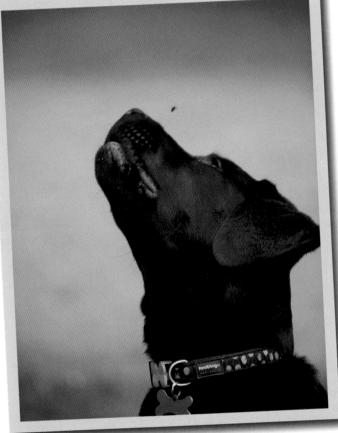

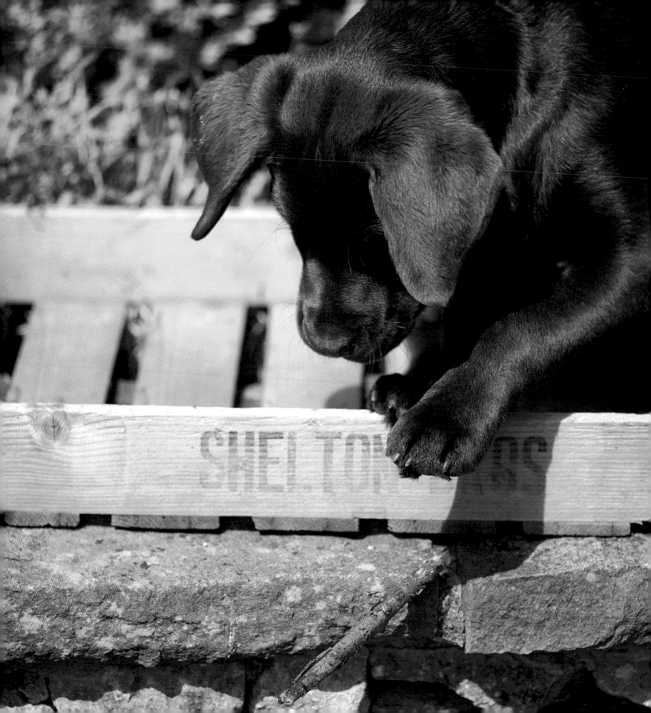

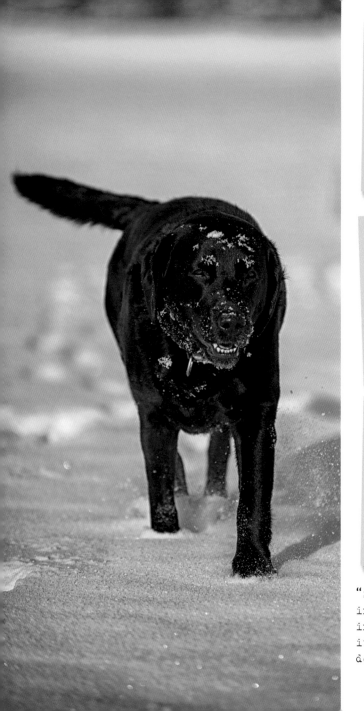

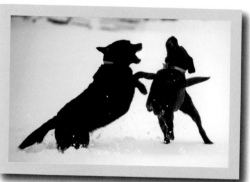

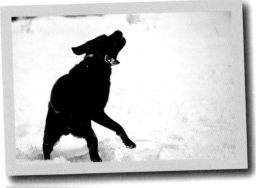

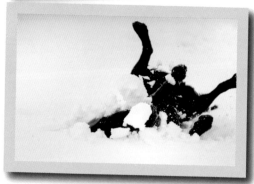

"Snow snow snow! We just love playing in it and never ever want to come in." (Dilly even cries when she sees it outside, and stares hard at the door handle to make it open!)

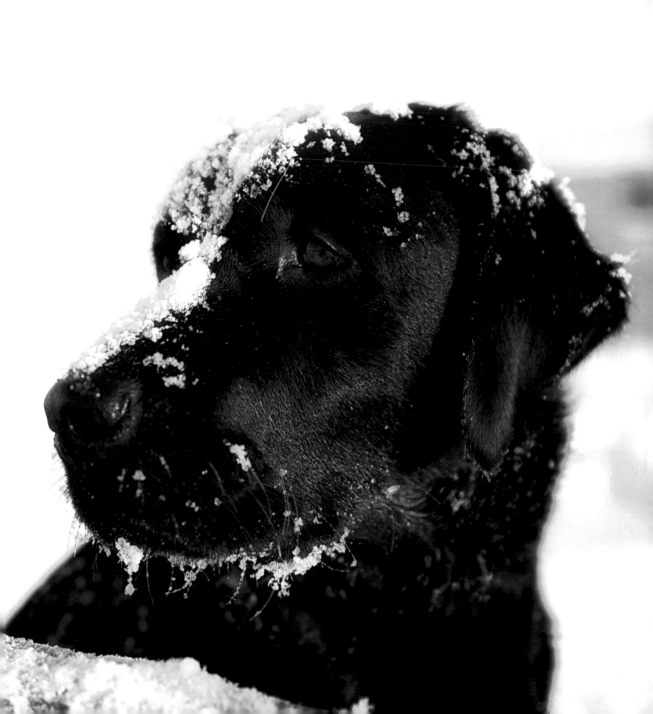

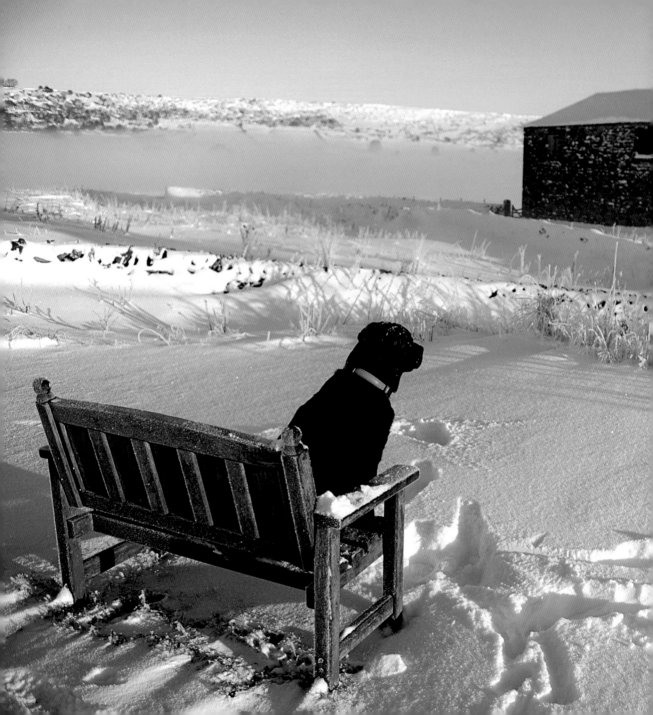

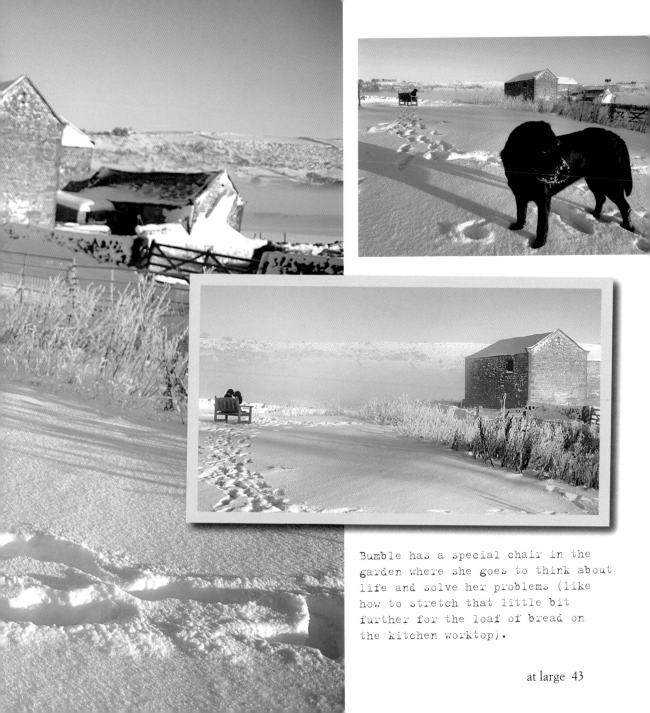

Bumble has a special chair in the garden where she goes to think about life and solve her problems (like how to stretch that little bit further for the loaf of bread on the kitchen worktop).

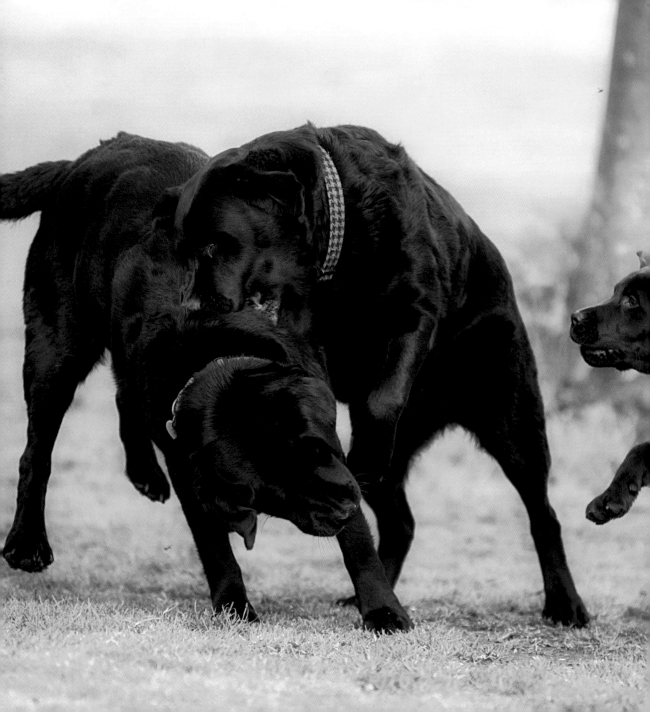

at play

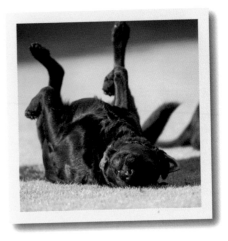

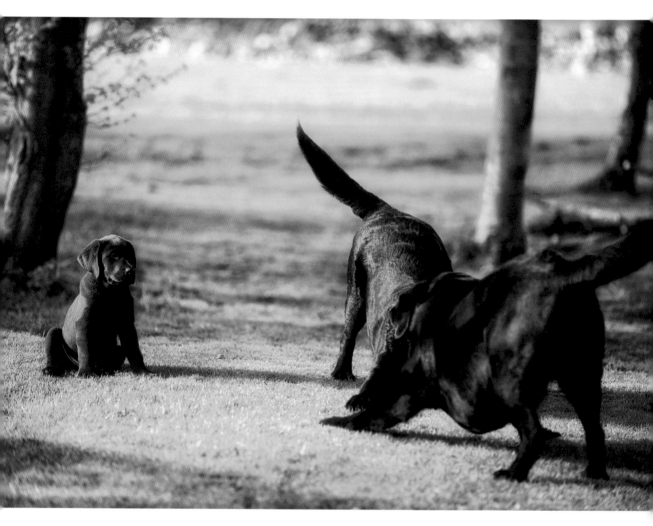

A young Barnaby watches the big girls play, and
wishes he was sooooo much bigger.

46 at play

When Barnaby was on television, he decided he really didn't like the microphone's attitude.

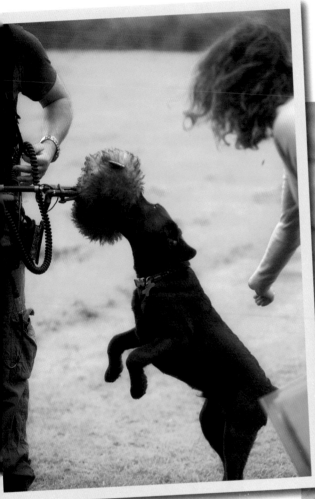

Catching balls makes your ears stand up—you should try it sometime!

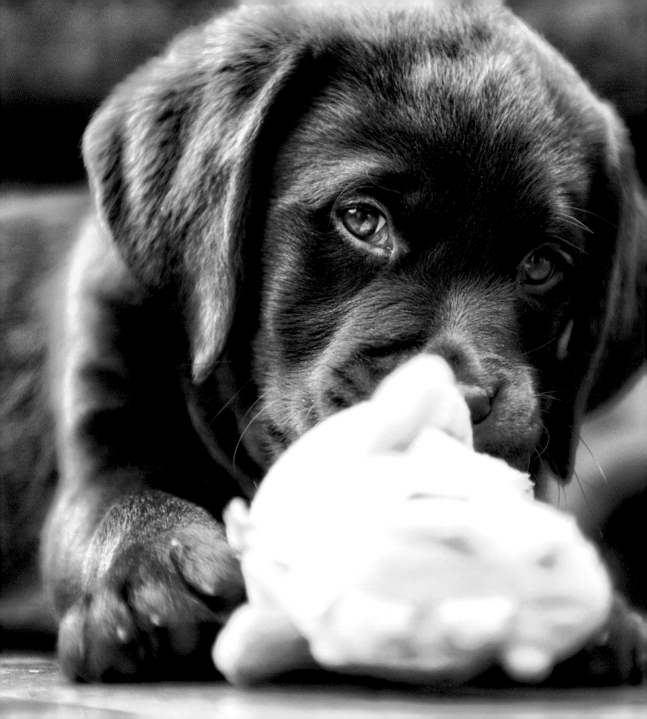

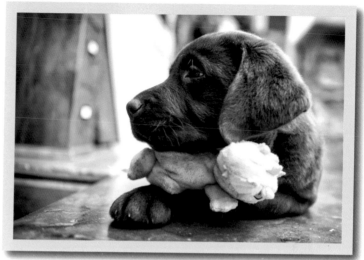

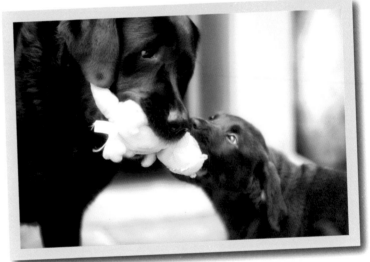

Playing with dinosaurs is a dangerous thing,
but Barnaby is of course very, very brave and
doesn't need Dilly's help, thank you very much...

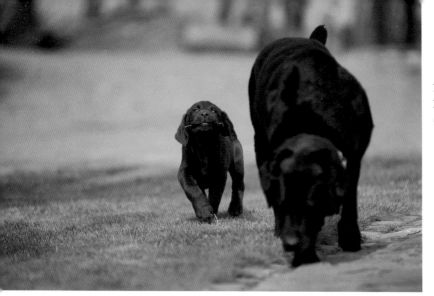

Barnaby shows Bumble just how well his training in carrying things is going.

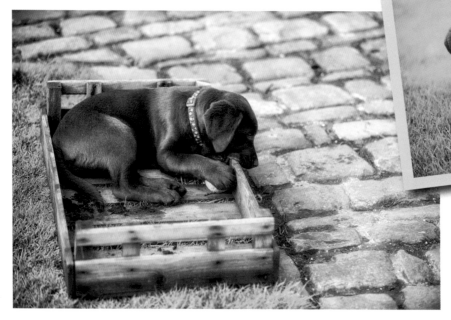

Some things you can chew (even though you're not allowed!)—and some things you can't.

50 at play

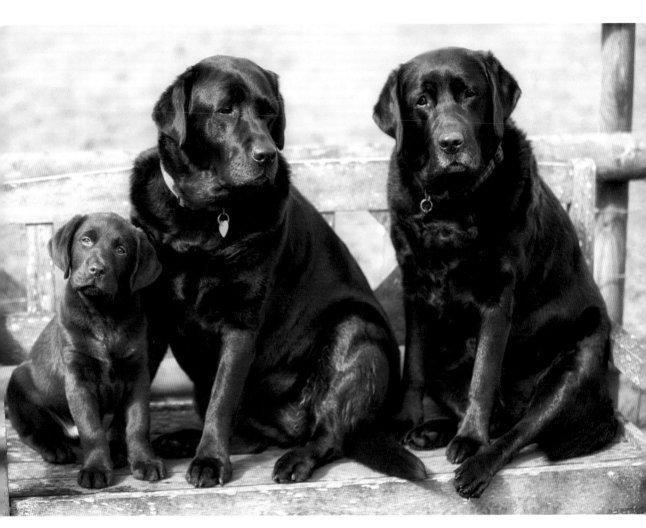

"What are you looking at?!"

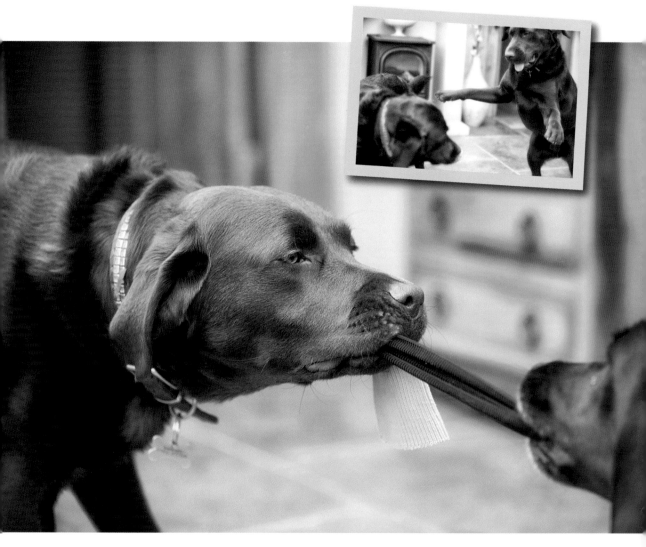

"Look Dilly, it's not your sock. Mum said I could
have it, so give it back nowwwww!"

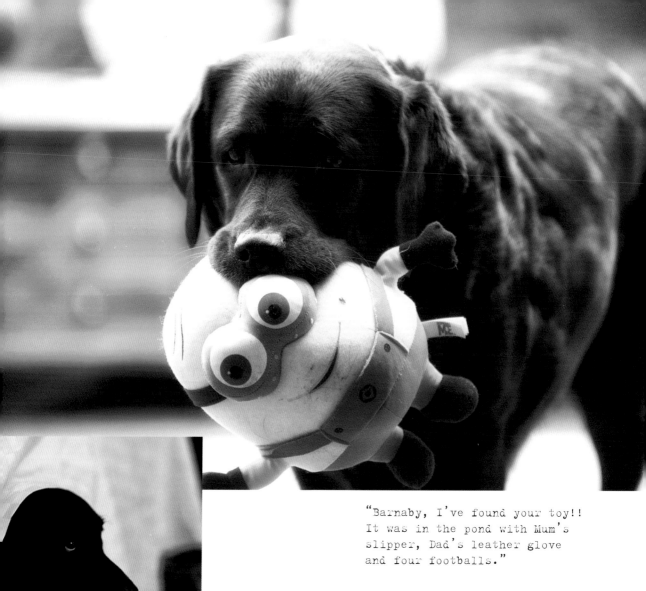

"Barnaby, I've found your toy!!
It was in the pond with Mum's
slipper, Dad's leather glove
and four footballs."

"If I hide under the table long enough, somebody's
bound to drop some food eventually, aren't they?"

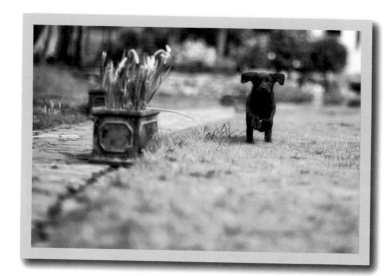

"My sisters told me that
if you run fast enough
you can fly. Here I go..."

"Flaps up..."

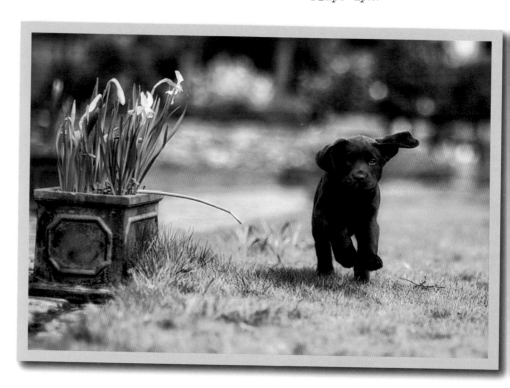

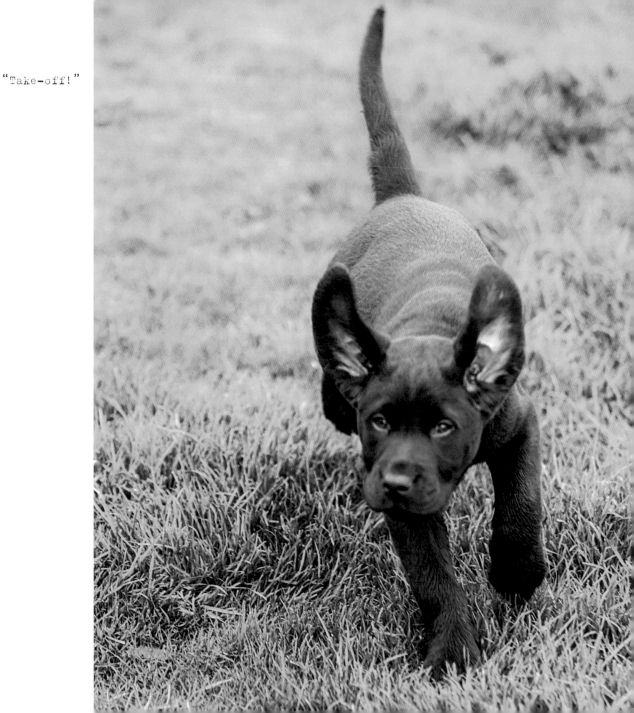

"Take-off!"

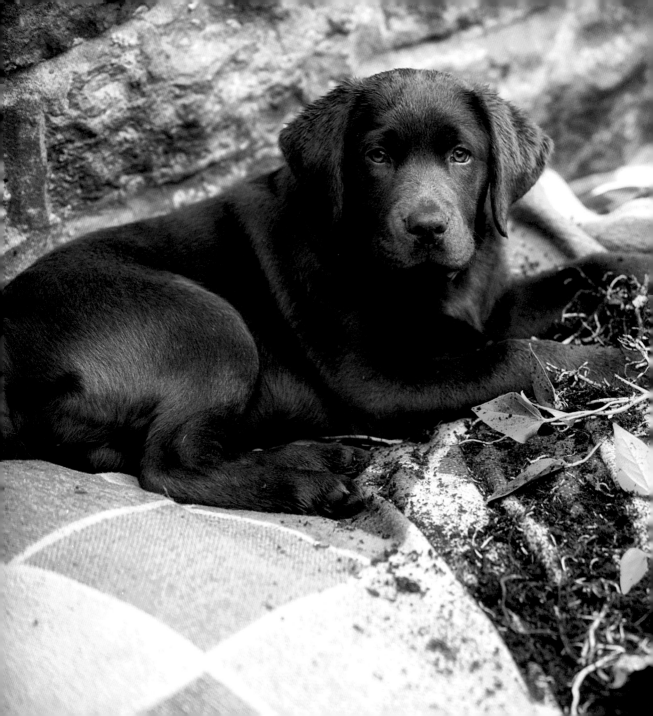

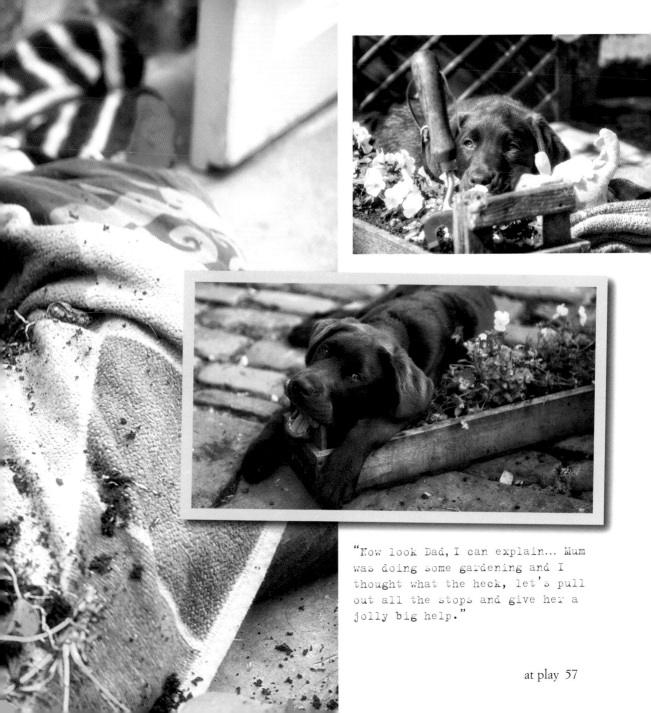

"Now look Dad, I can explain... Mum was doing some gardening and I thought what the heck, let's pull out all the stops and give her a jolly big help."

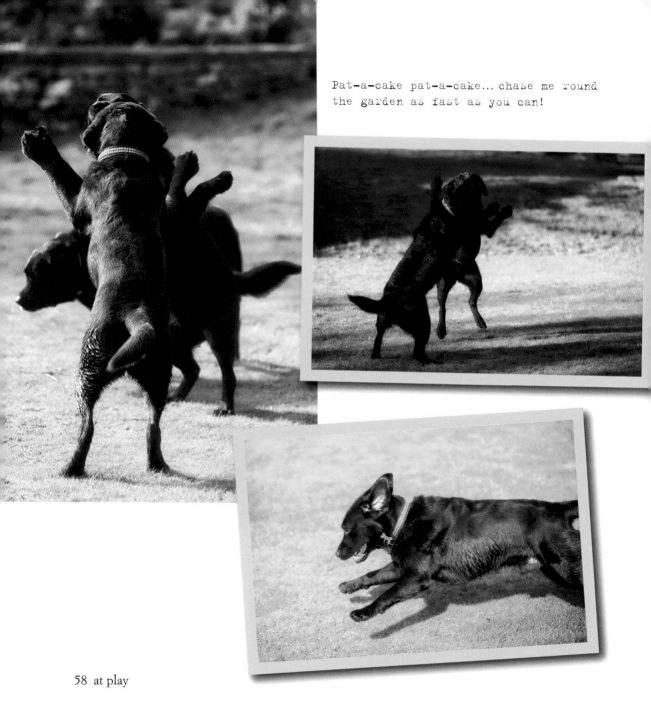

Pat-a-cake pat-a-cake... chase me round
the garden as fast as you can!

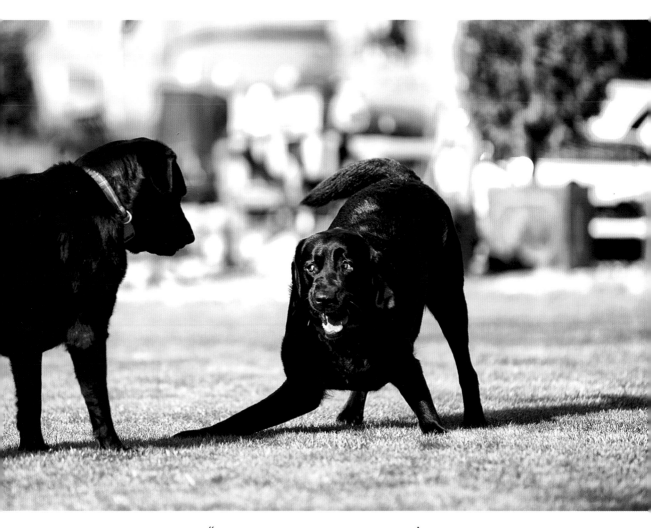

"One more step, Bumble, and I'll be round that
meadow so fast you won't see me for dust, big girl."

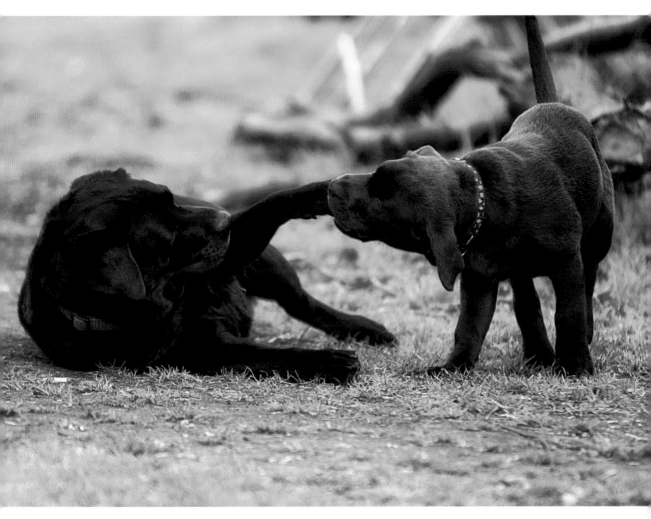

"Come oooooon Sis, it's not time to sleep, and
I wanna chase you round till I go dizzy."

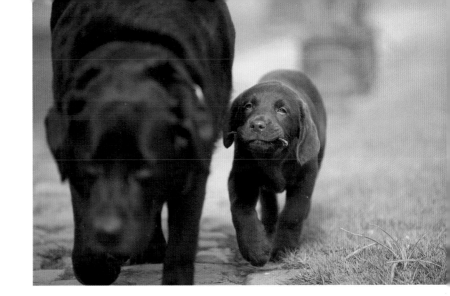

Dilly and Bumble spent
the day teaching Barnaby
"Tig" and how to lay as
flat as a pancake.

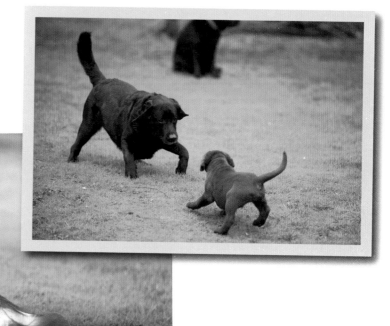

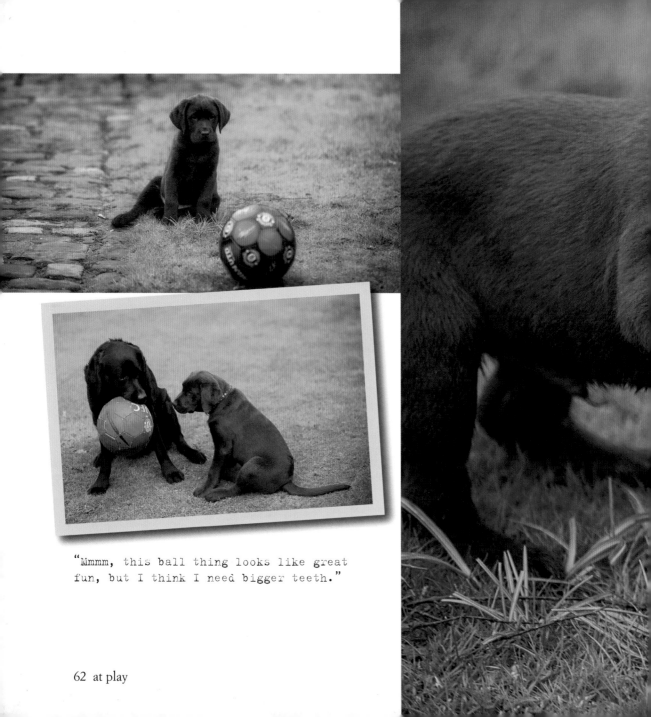

"Mmmm, this ball thing looks like great
fun, but I think I need bigger teeth."

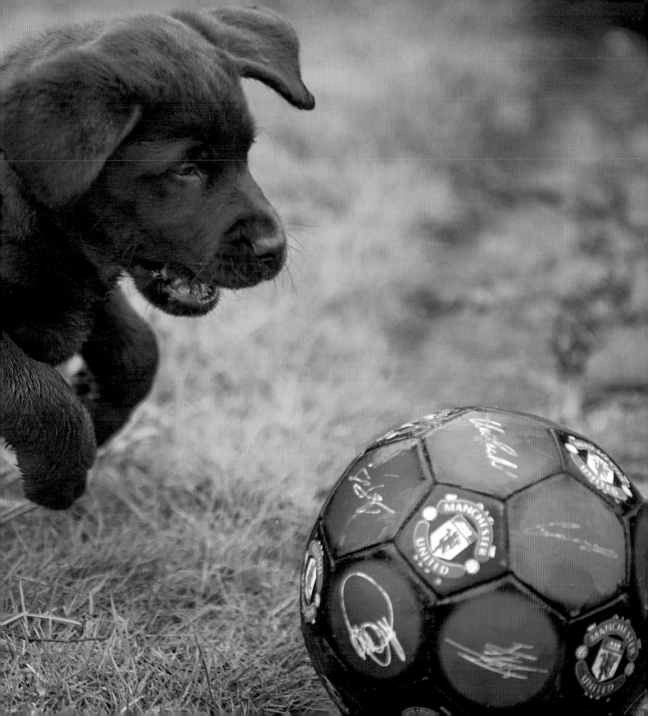

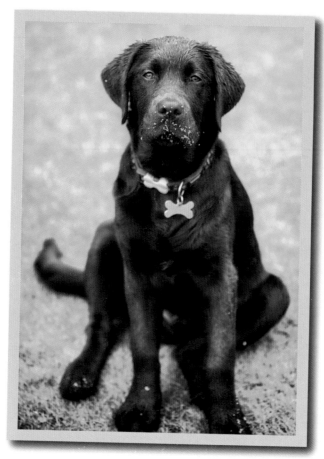

"Pond? Me? No way, Dad."

Acknowledgments

I would like to thank three members of my family so much for all their input and help in putting this book together. Without them it simply would not have happened, and to me they mean the world—Bumble, Dilly, Barnaby, THANK YOU!

Thanks also to my beautiful wife Jo and my children Hen and Oscar for putting up with my incessant snapping, and to Fee and Daz, for being brilliant partners and friends.

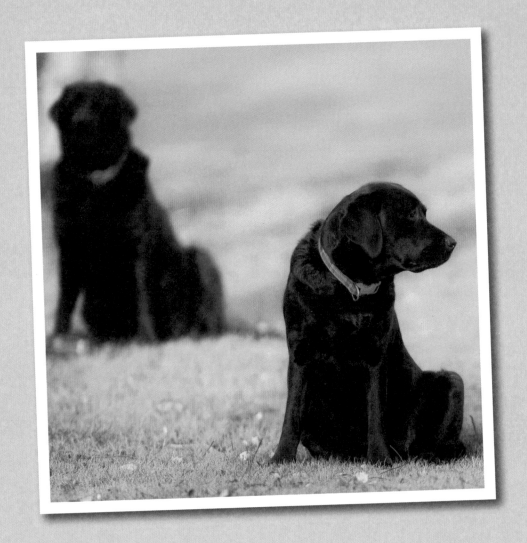